Legend of Artemis

Artemis is popularly known as the chaste
Greek Goddess associated with the moon and
with the hunt. This is, however, a reduction
of the power and awe her name once evoked.
Some modern scholars now trace her origins
to the Minoan Mistress of Mountains; others
see her as one of the many forms of the Great
Mother worshipped throughout the world
until she was displaced as a result of the
gradual imposition of patriarchy. Artemis
was goddess of all nature and thought to
inhabit groves, springs, forests and mountains
where country people worshipped her. Her
reputation as a protector of virgins is a sign
of the divine support given to women in
determination of their own lives, traditional
in matrilineal society. In the spring, woman
and girls danced, chanted and made music
in her honor.

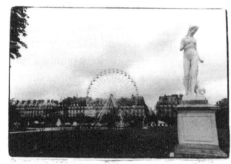

Artemis at the Tuilleries Garden, Paris,
Jeri Rogers

Artemis

Artemis encourages the development of local art and literature by supporting talent in the Blue Ridge Mountains and beyond.

The theme of *Artemis* 2014 is *Our Connection to Nature and Place*. Contributors submitted work reflecting this theme. In keeping with this organizing principle, the design and layout of *Artemis* is based on Sacred Geometry proportions of Phi, or 1.618, often cited as the most beautiful number in the universe. Despite its mystical origins, this number is considered to be the fundamental building block of nature. Recurring throughout art, architecture, botany, astronomy, biology and music, this number was named by the Greeks as the "Golden Mean" and also referred to as the Divine Proportion. The primary font used in *Artemis* is from the Berkely family, a modernized version of a classic Goudy old-style font, originally designed for the University of California Press at Berkley in the late 1930's. Rotis San Serif is also used as an accent font.

Cover Image: *Passages V* by Guest Photographer **Sam Krisch**
Title Poem: *Ego Tripping (there may be a reason why)* by Guest Poet **Nikki Giovanni**

Art Editor: **Jeri Nolan Rogers**
Design Editor: **Virginia Lepley**
Poetry Editor: **Maurice Ferguson**
Publishing Consultant: **Warren Lapine**
BMS interns, Floyd, Virginia: **Rachel Terrill, Camille Terrill and Madeline Emmett**

Printed in the United States of America

ISBN 978-1-62755-649-1 (Hard Cover).
ISBN 978-1-62755-648-4 (Soft Cover)

Artemis/Artists and Writers, Inc., P.O. Box 505, Floyd, VA 24091. www.ArtemisJournal.org

Artemis 2014 is dedicated to our guest poet, **Nikki Giovanni**, for her courage in times when her courage was needed by all of us, for her passion for justice and equality, for her zest for happiness and joy in herself and in others, for the shining example she has been for us, a beacon to guide us—to her, we at *Artemis*, give thanks.

"We write because we believe the human spirit cannot be tamed and should not be trained."

~ *Nikki Giovanni*

Table of Contents

Table of Contents

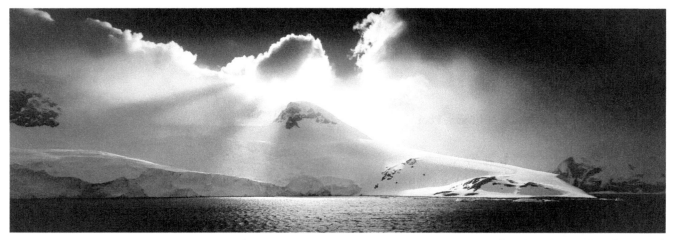

Sunrise, Antarctica, *Sam Krisch*

Ego-Tripping

(there may be a reason why)

I was born in the Congo
I walked to the Fertile Crescent and built
 the Sphinx
I designed a pyramid so tough that a star
 that only glows every one hundred years falls
 into the center giving divine perfect light
I am bad

I sat on the throne
 drinking nectar with Allah
I got hot and sent an ice age to Europe
 to cool my thirst
My oldest daughter is Nefertiti
 the tears from my birth pains
 created the Nile
I am a beautiful woman

I gazed on the forest and burned
 out the Sahara desert
 with a packet of goat's meat
 and a change of clothes
I crossed it in two hours
I am a gazelle so swift
 so swift you can't catch me

 For a birthday present when he was three
I gave my son Hannibal an elephant
 He gave me Rome for mother's day
My strength flows ever on

My son Noah built New/Ark and
I stood proudly at the helm
 as we sailed on a soft summer day
I turned myself into myself and was
 jesus
 men intone my loving name
 All praises All praises
I am the one who would save

I sowed diamonds in my back yard
My bowels deliver uranium
 the filings from my fingernails are
 semi-precious jewels
 On a trip north
I caught a cold and blew
My nose giving oil to the Arab world
I am so hip even my errors are correct
I sailed west to reach east and had to round off
 the earth as I went
 the hair from my head thinned and gold was laid
 across three continents

I am so perfect so divine so ethereal so surreal
I cannot be comprehended
 except by my permission

I mean...I...can fly
 like a bird in the sky

Nikki Giovanni

iPhone Photography: The Serious Work of Play

In 2010 a friend and I were enjoying lunch together. He held up his iPhone. "This is the future." I shrugged and went back to eating my chowder and then he took my picture, made me look like a comic book character, colored it with a stylus and put a bubble over my head saying "iPhone Apps are my happy juice."

I usually use pro cameras to make images of large landscapes, large both in the amount of space captured and the ultimate print. However, he intrigued me. I went home that evening and checked out the most popular apps. There was one called "Hipstamatic" that I started using. It created aged, square photos as if they had come out of an Instamatic or Holga. I used it to take pictures of everything: flowers, still lifes, landscapes, street photos, abstract light and shadows, even nudes. I often would prefer the iPhone images to those captured with the pro camera.

There was a sense of play, a sense of whimsy, and a sense that these little digitally-aged photos were from another time and another place. I reveled in the irony of using the latest technology to produce extremely old looking images. It was as if I was creating nostalgia for the present.

As time went on I wanted even more flexibility. I would use the regular iPhone camera and then process the images in one or more apps. I would post these images and people would sometimes say that they looked "painterly" or "vintage". The next comment was always the same: "You took that with an iPhone?" I would answer that I not only captured the image, I also processed the image using the iPhone. Sometimes I would give them a demo. There was awe and sometimes frustration that you couldn't do that with a traditional camera.

There is a trend toward using four or five apps on an image, sometimes over-baking the cake. On Instagram some photographers hashtag a proud *#noFilter*. For me, it's not about how much work you put into your image. It's about how it works. Photography is an interpretive medium. Play and different perspectives are important in creativity. If you don't like everything that you see through a camera, take two steps to the side or turn around. You might see a whole new world.

The iPhone image **Picnic** (at right) was captured using Hipstamatic and aged using Swanko Lab, with additional editing in Photoshop to prepare for printing.

Sam Krisch

Picnic, *Sam Krisch*

String Theory, *Tricia Scott*

A Curtain of Stars

The needle repeats
with imperfect persistence
dotted thread lines,
new meridians in cloth,

stitches connections
between constellations,
binds warm lining
to a curtain of stars;

a seam that would
only compliment
the cloud-free night
should it appear there

suddenly crisscrossing
the Milky Way.
The spirits of the stars
are with us tonight

watching from the heart
of the fire; sparks rise
to the flue as you stitch
a new cosmos together.

Mike Allen

Bridge to Woodall

There must be a thousand eddies on the Chattooga River
between the bridge and Woodall Shoals, and after work
when the trips we guided were soggy memories, we'd catch

all of them, boof every angled, sloping ledge—rontwards,
backwards, edgewards, upside-downwards; we'd surf every wave,
from the least dimple to the pulsing monsters that formed

at highwater, when the Chattooga's amaretto ran whitecapped
and fast, eroding banks, tossing deadfall as if carrots
in a giant's mouth. Fiends for breathing that galax-pungent

escarpment air, we'd put-on with haste, always ferrying
across to the South Carolina-side, first, to check the gauge,
and then do a couple of rolls, a couple of pivot turns

if the boat was low volume, making sure the skirt fit right,
that it wouldn't pop on the first ender at Surfing Rapid.
Sometimes there'd be old-timers in the shallows, turning

over rocks for jackdogs—catfish bait—& they'd look at us
the way shopkeepers look at skateboarders who are surfing
the sidewalk in front of their store—techno weenies

no matter how hard we tried to be retro, in our snazzy
lifevests, our pink brain buckets. A curious hunger
drove our play—part-obsession, part-adrenaline,

part-longing to connect with gravity, time, water,
earth; but mostly just each other, ourselves. There
was no garbage down there, no roads and no homes,

Clouded Reflections, *Lauren Jonik*

only lines, new & old, and depending on the water level
and what sort of boat you wore, and how long you'd been
wearing it, & some coefficient between where you wanted

it to go and how well you visualized it getting there, you were
on line, or off; at Surfing Rapid, S-Turn, Highwater Hole;
at Rock Jumble, Woodall, Screaming Left Hand Turn; lines,

eddy hops, elevator moves, backferries into sidesurfs,
screw-ups, three-sixties, pirouettes. "Hey, follow me,"
one of us always said, already getting momentum,

ninjastroking the little plastic casket, about to slice
into the meat of some frothing curler, some uniform pourover,
or tripped-out creekslot; and we did, of course, every time

and gladly, like disciples, hungry for salvation, we followed.

Thorpe Moeckel

A Crow Watches

A tractor, patches of red scattered on its frame,
has sunk into its final stop. The horse shivers
his shoulders to shed flies. His back sags.
A pole, once the center of a haystack, leans.
The barn roof crinkles, its sideboards flap.

One lone crow watches from the tractor's rusting seat.
A farmer picks his way toward the barn
along trenches deeply worn by wheels and storms.
Inside, are his tools of the past – scythes on nails,
sickles with bent blades, broken pitchforks.

A shroud of dusty spider webs wraps horse collars.
Harnesses, with deep, dried crevices hang,
no longer up to the pull of a horse.
Dirt, mice trails, baler twine in swirls cover the floor.
A dried snakeskin curls from a knothole.

The barnyard is a graveyard. Once modern machines
for hay making are in stages of decay:
a deformed hay rake, with teeth missing or bent,
a hollowed square baler, a wagon with rotten planks,
its tongue buried deep in the dirt. And, giant Dock weeds.

The horse eats hay from modern, round bales.
The farmer stirs history with his boots.
Each sunrise the weight of time piles higher.
The crow spreads his glistening wings.

Al Hagy

Rising Star, *Jeri Nolan Rogers*

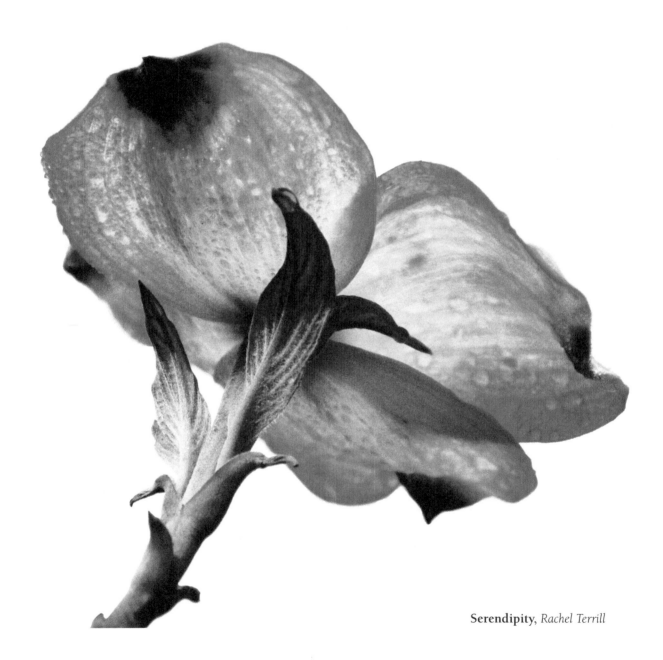

Serendipity, *Rachel Terrill*

Thistledown

Seems to me,
if you're doing your job,
that's the sort of thing
you oughtta be
going after.

Something that
lifts itself
from the page
unexpectedly
and
takes to the wind
traveling for miles
then
settles somewhere
where it stays.
Up to ten years I was told
by the old clodbuster
who spoke to me of such things
as no one else could

Something that rises and sails.
Something that travels then settles.
Something that settles, stays.
And—a decade down the line—
sprouts.
Takes root.
Grows.
Then flowers
until the flower explodes
in a radiant spray of
possibility.

Give me a poem like that.
Give me one in a lifetime.

One.

And I'm good.

Curt Alderson

The Collector

Leave me alone
to press my thoughts
rare flowers
in a hardcover book

Give me time to write lyrics
to the melody of morning
to pray on a rosary of silence

I need to measure each day
by the stretch of light and shadow
see the moon as a bowl
fired by the sun

I want to make a fossil
impressed with a feeling
until its innate memory shines

Let me steal a few moments
to collect an intuition
to look an untold story in the eye

Colleen Redman

Pandora's Friend, *Susan Bidwell*

Dragonfly, *Camille Terrill*

Revelation at Philpott Lake

For George Byrd

I don't think the soul leaves the body;
it has to be the other way around,
the way a berry leaves its bramble
or a bird leaves its nest.
It has to feel a little like I feel
after I swim and I leave the water,
my arms leaving a whole lake behind.
What if the body leaves the soul
to give the soul more room to wander?
What if the soul is thankful,
hovering, a dragonfly over water?

Felicia Mitchell

In The Evening After Work

It's a green task
our walking into the unknown
where day slips

so easily into night
at no point can we say the death
of one takes place

and the birth
of the other. It's a green task
our conjuring

of clouds
in their white disguise, mute
witnesses

to an unconcern
for the destination toward which
they are inevitably

moving.
It's a green task, this stirring
of thought

as we move past
the alligator bark of a tree, the blue
leaves of the hedge

turning up
like the eyes of a debutante, the wind
teasing our lips

like the third party
of a love triangle, and the grainy edge
of the pebbled path

the margin
for the essay we are writing on the air
between us—one

that confirms
our conclusion: the shadow of our linked
arms in the still water,

the moon, resting
on its dark surface, a neon wonder
the color of butter.

Llewellyn McKernan

Artemis

Amazon on mountain top,
moon traveler of night ways,
great she-bear see
the questions of life
as now you must hunt
those once nurtured.

Move fast lonely one,
whisper within and out,
wind storm passions have
blown through your breast
for these can yet emerge
as dreams still tender.

Sherrye J Lantz

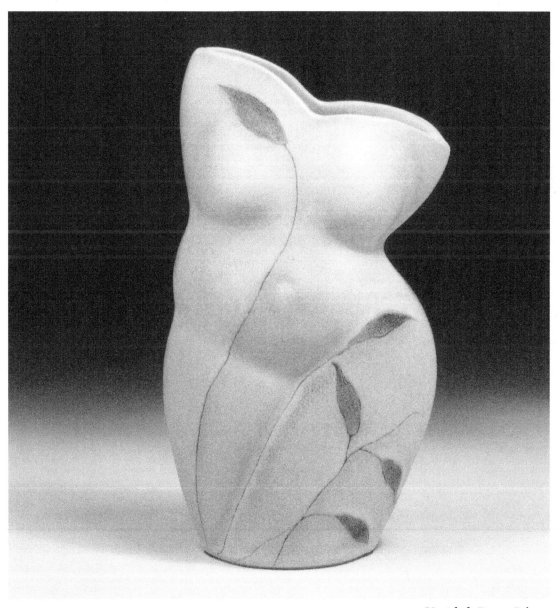

Untitled, *Donna Polseno*

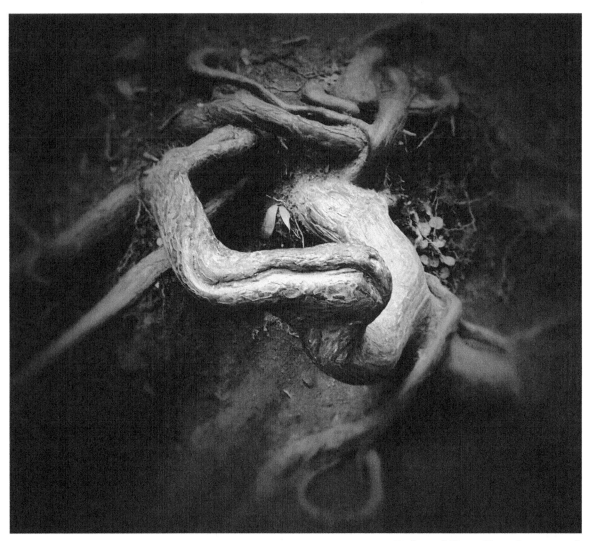

Redwood Knot, *Karen Boissonneault*

Cello

It captures the sound of the earth,
creaking with the burden of revolution,
and the roots of great trees reaching deep inside,
curling round the axis. It sounds the dappled,
the luminous golden-green of thick foliage, of sunlight
lapping against wide, aged trunks. It rises,
richly sonorous, and pulls at each filament
of the spirit with familiar notes—the soft mellifluous timbre
sliding like warm honey into perception. Thick, supple,
sweet, an old voice lives in the wood and the strings,
a cantor of primal invocations, of heart-melodies.
Tracing the gnarled bark and the wandering roots
to set the earth reeling for rebirth.

Emily Michael

Dwelling Place

You lean against a red maple,
listen for the sound of sap,
but like your own blood,
you cannot hear it flowing.

You press harder against the tree,
wanting to feel its pulse.

Your skin grows gnarled and knotted.
The bark's sweet smell
becomes your sweet smell.

You draw in the sun's warmth,
drink the rain.
Dressed in leaves,
you grow roots.

B. Chelsea Adams

Marigolds

In summer near Mount Solon, my grandmother's garden
sifted through sunbeams in a green, fenced square beneath the screened-in porch
where in the heat of the day she would let me
sit on the cool divan and sort through the browned photographs
of my uncles, at war, thin, tan and grinning
in heated lands of lost flowers.

My grandmother's garden had zinnias and marigolds,
blue hollyhocks, and bumblebees
amidst the cabbage, and pole beans, tomatoes.

The barn was further down the path
and further yet the little creek where my grandfather taught me to catch bream
and cook them in a skillet at breakfast with buttermilk biscuits and cow's soft butter.
The white-washed shed held secrets of jellies, and last fall's hams,
and a pool table.

The men we didn't know were in the next town planning, they were, talking big,
thinking to stretch a highway and dig an airport in our Valley before another war.

But August at the farm, along the dusty lane, above the spirea,
a tomboy napped and
the sepia'd shots of brave uncles slid like dew-grass to the floor.

Marjie Gowdy

Barn at the Blue Ridge Institute and Museum, *Caroline Leggett*

Honeycomb

Cigarette burns on windowsills.
Calcified bodies of bees.
Children's fingerprints on glass panes,
names smeared across autumn-steamed windows,
Ann Jane Mary-Kay Gretchen,
signatures as varied as our hair,
brown blonde curly straight short long.

Corncobs in the bedroom walls
where fat rats stashed food for winter.
After the cane fields burned and
the temperatures dropped
they scratched and nibbled
all through the night—
an inch of wall between us,
so close they could hear us breathe.

We snuggled under thin blankets,
listening on windy nights:
pecans pelted the sides of the house,
thuds and plunks on the roof,
gas heaters hissed and purred.
The bones of our old house
creaked and groaned
as we settled in for winter.

Every spring the bees returned,
hotly humming inside the dining room wall.
After school, a sprinkling of thumb-sized bodies
littered the floor where some squeezed in.
Barefoot and hungry
I hopscotched my way to the kitchen
conjuring biscuits and honey.

I imagine honeycombs inside those walls today,
dark gold and time thickened,
hard as amber these decades later.
Are our long-ago words trapped inside, too?
Can voices stick to honey?
Mother reading "The Listeners": *Is anybody there?
asked the Traveler, knocking on the moonlit door…"*

Seasons came and went on the River Road.
And one season, we did not return.

Did we leave part of our selves?
Where do words go?
And the harmony or dissonance
with which they are spoken?
Somewhere inside those walls
surely the hum and tick of our lives
reverberates still
beside quiet honeycomb, decayed corncob.

Are we still there? I wonder,
Traveler and Listener both,
as moonlight shines on the closed door
of our old River Road house.

Jane Goette

Return

After the cutting and the poisons
I take my old dog, who is blind,
Onto the path winding beside the choke cherry and brambles,
The milkweed that bobble their soft, purple flower heads in a small breeze.
We pass beside the creek
Where the black willow stretches out her limbs along the bank
And tosses her hair into the water eddies,
The marsh, where frogs slush into the water at our footsteps,
And the red winged blackbird poses on a high stalk
To fan its brilliant stripe for us.

We step out onto the field that flows away in waves of grasses
To be held by a ring of blue mountains.
The field, where we have watched and smelled and heard and touched
All the seasons dance and turn
And turn again.
We climb the first small rise
And among the sentinels of the orange broom sage,
We lie down.
And my old dog places his muzzle in my palm.

The sky and the clouds of the day pass over us
And the shadows of the trees at the field's edge move across us.
Still we lie there.
The evening swallows stitch the air above us
And the smell of dark gathers.
Still we lie there.
We lie in the field until something ineffable
Passes from the skin of the earth into my skin
And then we rise,
And without stumbling,
Find our way home.

Diane Goff

Dungeon, *Jane Gabrielle*

The Hermit

Who can hear my voice?
In the wilderness of souls,
where each must walk alone,
where thought, perceptions and belief
form crags and stony plains,

because I have learned caution,
I use gifts once wasted—
lantern, staff and focused eye.
One must find the path
among tracks of feet unseen

and test the barren ground
before each step. The task
is to discern the rocks
of truth from those of
elements less rare. No map

can help; I tread where
wisdom hides and folly calls,
in land I made. Myself
I seek. The shaman first
must plumb his own abyss,

learn to fashion ways and
ends as one, find the
vantage point from which he
sees that to the base of
every cliff winds a path.

Brad Burkholder

Plath's Boy

Ted takes him to
cricket lessons

where they compare
animals in a sonnet

three poets in a family
sipping coffee

with cigarettes
in a Cezanne ashtray

walking over ghosts
on a noon stroll

dry metaphors
dancing under them

dryads spinning—
lost in the trinity.

Eleanor Levine

Before Daybreak

Heard the death screams of a hen
shortly before daybreak

Shot the possum

My son is proud of me because he thinks
I finally learned to shoot

Didn't tell him about the clutch of day old chicks
I stepped into
as I ran down the path toward our chicken house

Didn't tell him that I don't remember
shooting the possum 5 times

I only remember the feel of those soft warm babies
breaking
under my bare feet

Pat West

Living with Chickens, *Pat West*

Summer Solstice, *Dan Henderson*

Passion & Tangles

After Ruth Ellen Kocher

blue heron spread its wings across lake evans
you find a heart carved in
montezuma bald cypress
tough rough skin

I might say this tree is sacred
worshipped by natives in mexico

spiral leaves
canopy of branches
cypress knees for roots

fishing line almost strangles
mallard duck
you would never say men originate from rocks or ocelots

I'm thinking the Cahuilla Indians hunted
game at Fairmount Park before horse-drawn
wagons
dipped buckets
in the clear stream

did you know
ancestors originated from earth from caves
trees to Jaguars into people

he didn't seem Upset to cut the thick branch
arching over the lake
framing snow-covered mountains

carousel gone families gather for car show, bbq
we share the Desire to keep this park clean

Cindy Rinne

Path

Love to roam
a tiny piece of the Blue Ridge from field's edge
to Borden's Run where the waterfall meets the ruins
and the Indian Paintbrush defies the power line.
Love to tread
where the Trillium lines the dog path
and the Columbine and Rue push their way between
the Redbud roots.
Love to bound
over the padded path that leads to the Sassafras and Rat bane
then jump the mountain spring that feeds the
Mayapple and cress.
 Love to listen
to the creek water as it rushes
under the locust slat bridge
toward the old Indian swimming hole.
There it gathers, then pushes on to the waterfall
framed with ferns.
Love to catch
The Showy Orchis flaunting pink magic before
it vanishes into summer earth.
Love to chronicle
the native show against the fallen Ironwood wrapped
in twisted grapevine and Honeysuckle.
Love to depend
upon its strength and variations
from March to December, then
breathe its coming from December to February.
Love to gaze
into the high field of white lace and purple Lobelia
and believe
this seasonal grace reveals the beautiful
truth
my heart has come to know.

<div align="center">Patricia H. King</div>

Walking Stick Left for the Next Hiker,
Diane "Dee" Bowlin

Hours in Early Winter

This November light is thin and gray.
The whole month knows life is dwindling:
crabapples rot, the woodpile thickens,
flimsy shells of crickets freeze on the stoop.
Smoke fades through the sky.

My clock unwinds with fervor, gaining an hour.
Watches stop on themselves, second-guessing,
as time unreels like a strip of wronged film.
A fury of minute hands skip back,
dragging sunset, dinner, and bedtime.

November, cold and flat, contains
the chill, still air of the hunt.
This month is a seeking of glory,
and the awareness of being sought.
The minutes unfold, and then stop.

There is no plot, no story, and no end.
Those thirty days are uninhabited minds
motionless within themselves.
There is only the hint of winter
and the turning of minutes.

Pauline Pauley

Civ-i-li-za-tion

Tall buildings
sporty cars
300 dollar shoes
designer blues
the music's on mute
the scribe's out of the loop
the dance lacks
expression
cultural savages
satiated on formula
television
and laugh tracks
telling us when to
smile

Joanne C. Hillhouse

Nature's Palette, *Gwen Goepel*

Dawn Landscape

The crimson-black of dawn spreads
Like a fever across this morning-still

Lake, that long, soft ridge of Woodbury
Mountain, before it alights up the isolated

Loons that visit our dock: so close I know
Not where their home ends and ours begin.

Sean Prentiss

Ballad of Frida Kahlo

Frida ain't free
Her wings are broken
like her spine
streetcar named desire
pierced by 3 swords
Tho her image multiplies,
she is singly one
wounded deer
the slaughtered fruits
mango and guava juice
seedless grape
peel away the layers
of artichoke
desire is the heart
at great expense exposed
the dream of drowning pool
her empty dress holds ghosts
of phantom pain rocked to sleep
in abysmal light
the world is a lullaby tonight

Margaret Manuel

Always the White Whale

Always the white whale circles my boat,
Threatens to sound just when I have glimpsed
the mystery behind his huge blankness.

Why does nature allow the corn to stand so late
Into the fall, sustain the darkness between the rows
where the answer to "What's in there?" hides,

permit a fallen nest with one last
blue egg not to tell me what has
happened to the other two,

withhold the reason why in the first warm joy of March
the peach bough, heavy with its blooms, must
break and fall to earth as if designed for death?

Yet if we had the answers,
the story would end, and we
would drown in Ahab's ocean,

find monsters too horrible to name
 within the corn, discover who had
pushed the nest out of the tree,

and that we all have winters in our souls.
And so, the rest, indeed,
must be silence.

Barbara F. Stout

Crane Ewer, *Silvie Granatelli*

Sunrise: Cades Cove, *Aileen Blankinship Fletcher*

Auspice

At sunset, red masked, the Muscovy hen
leads her meandering, oblivious brood
over the exposed live oak knobs, protruding
like pipelines along the morass shore bends.

From across the pond speeds the despotic drake,
Self-ordained baron of this harmless flock.
Quivering with rage, he lets loose a squawk,
A diffident attempt to intimidate.

The hen hides her ducklings behind a root,
bristles back, and quacks at the bold intruder
then beats her dauntless pinions at his face.

A violent scuffle, and off flies the brute,
skimming the pond in a bewildered flutter;
he spends his evening preening in disgrace.

Mark Petrie

Territory

A crow is
battering
an osprey
in the thermals
above the river.

The silver bird
appears
bewildered
by the black bird's
pertinacity.

It is just those
two, though
the air is raucous
with caws from
the flock.

The sycamore's
ghost arms
extend to catch
whatever
the sky surrenders.

Ann Goette

Pantoum for Attachment

My sister the Buddhist says it's my problem.
I say it makes sense I don't want to let go
the hand of my daughter as she sleeps into morning
in the bare room, or the bare room itself for that matter.

I say it makes sense I don't want to let go
—the worn rug, the coffee mug left on the mantle
in the bare room, or the bare room itself for that matter,
the million invisible atoms we're breathing,

the worn rug, the coffee mug left on the mantle,
the half-lit smile she'll make when I wake her,
the million invisible atoms we're breathing—
I want it, of course, I want this touch to become

the half-lit smile she'll make when I wake her,
the nutshell of her small brown head.
I want it, of course, I want this touch to become
enough for the rest of whatever is coming.

The nutshell of her small brown head
turns in her sleep like agreement, cunning
enough for the rest of whatever is coming.
A bird cries morning. Watch as she

turns in her sleep like agreement, cunning,
into a woman in a raincoat by the side of the road.
A bird cries. Morning. Watch as she
(anyone, not my daughter, this other, this vision

of a woman in a raincoat by the side of the road)
walks under the sky as if it were breathing.
Anyone, not my daughter, this other, this vision
I must, my sister says, release. She

walks under the sky as if it were breathing
in all the loose thoughts of a collective sun.
I must, my sister says, release. She
doesn't understand. Why should I let go?

In all the loose thoughts of a collective sun,
where lies the love my grasping mother-love
doesn't understand? Why should I let go
of her tender-boned, still small hand

where lies the love my mother-love
finds a nest to rest in? I would make a sculpture
of her tender-boned, still small hand
—a totem to carry against the future,

a nest to rest in. I would make a sculpture—
the hand of my daughter as she sleeps into morning,
a totem to carry against the future.
My sister the Buddhist says it's my problem.

Mary Crockett Hill

Almost Done, *Michele Rice*

Signs

I. The Istanbul Flat, 2013
In Istanbul's azure slant I see it the minute I return,
still as an inkless quill, a white feather on the floor:
light in my hand, frayed envoy, a means to pierce
storm and fog, a known symbol of beauty, free will.

II. The Cottage Above Twelve Pole Creek, 1946
My freckled-face mother shouts through the strands
of her coarse red hair flying off its pins and down
across her skittering blue eyes. A bird in the house,
disaster, betrayal! There are those who know signs.

Windows full open to gather any drift, she flails
gnats, summer inside air. Suddenly, vermilion fans
across the papered edge toward the prim glass lamp
with the orangey shade turned so the torn seam is hid.

Mother calling, Oh Lordy, a token! grabbing a broom
and sweeping up toward the ceiling as we three kids
dance on bare soles. We plainly see she doesn't want
to hit the bird, only shoo it out where it's not a warning.

III. The Istanbul Flat, 2013
Last evening, gulls swarmed radically between high-rises,
their white wings flat and shadowed under the mystic bank,
an omen that hung above the city like an drape of despair.

From a neighbor's roof, this feather likely fluttered in
while traffic soared from freeway to Bosphorus today.
Here, on a top floor, I watch the gulls come each night.

Even in this corrupted air, they can survive a long life.
At night in mass, they look like a horde of feathered boots
without legs, each assuming their rights to claim a red tile.

When the first radiance trembles open the eastern horizon,
the nimble gulls lift out to survey the trash, skim the seas.

IV. The Cottage Above Twelve Pole Creek, 1946
Daddy, trying to look unalarmed, angles forward,
up from the green checkered couch and staggering

says, ...no need to waste sweat trying to stop it
before it gets here. Besides, it was us

left the window up and all but invited it in.

The 1947 flood devastated but did not ultimately destroy.

Judy Light Ayyildiz

Bent Mountain Marsh, *Gina Louthian-Stanlely*

California

I just wanted my feet to touch the sand
I wanted to feel the waves brush the cool brine over them
If I could just have a day on the beach

I wanted to start up a bonfire and smell the wood burning
Use the heat to warm my hands, and our dinner
Grab a few blankets and stay the night

I wanted to hear the seagulls and feel the sun hit my cocoa skin
I wanted to feel the wind hug me like a close relative
I wanted to be in the presence of fresh smog free air

Until I got there…
The sand oil filled, the brine murky and brown, and the trees all chopped down
The seagulls all diseased and grounded while the sun blistered without ozone around
And the wind…..the wind only blows the smog to my lungs

I was too late

Jordan Holmes

Charles Darwin

He's standing in his garden
at Down House in Kent,
but he's not studying
large beds of *Linaria vulgaris*,
not taking notes on growth rates
of one bed compared to another.
He is not standing with a colleague
expounding the virtues of cross-
versus self-pollination.

Today, Charles Darwin holds
a fallen fledgling. He is unconcerned
with which species of songbird,
its traits, latinate names
for feather anatomy.

The throat is weak
and can't lift an impossibly large
head, the beak opens
and closes slightly,
barely audible peeps, arrow-like,
pierce the listening air.

Though Mother has been dead
since his eighth year, Charles
turns toward the house
and looks for her, he wants to ask
how to revive this trembling
galaxy of thin feathers,
the darkening, milky planet of the eye.

R. Elena Prieto

Green Tara, *Kurt Steger*

Winter Sparkler, *Colleen Redman*

Ice Storm

The icicles hanging from the tree branches outside
my window are close dancing together in suggestive tango
now that last night's wind has died down.
They have frozen saber sharp, diagonally,
Now jitterbugging into sullen solidness in the storm.
Summer is a much better chaperone,
heat keeping things apart, until they melt together.
This first day of winter has said, "Time to slow things down."
The moaning pitch of the wind orchestra goes down a couple of tones,
even though it is still in a minor key, a dismal dirge,
and a scale untaught in conservatories.
The parent ice has asphyxiated the streetcar wires, such a bad example.
There will be special streetcars with blades on the trolley poles
to strip the ice from the strangled copper lines,
jaws of life for the current to escape.
Even the green and white commuter trains whose rumble
I can tell time from are lurking motionless in the stations
Now the icicles closest to the street lights drip heavily,
already frozen by the time they hit the pavement.
I still have power, the Christmas lights in the apartment
and the lit antique lamps in the store across the street
waste electricity our darkened cold powerless neighbours
to the north and east of us would appreciate.
The light and heat escapes from their windows
only to disappear into the Siberian sidewalk,
the pedestrians trudging like Zhivago on the
gritty gulag of salt and slush that destroys
even the sturdiest boots or the resolve to keep going.
The cutter tram grinds by, slowly, waltz time,
but as noisy as a military icebreaker above a lurking submarine.
An hour later, the streetcars are back,
singing their lullaby in a great aunt's grating voice.
Oh, please, make winter sleep.

Lucile Barker

Crown Imperial

The new house has flower beds as orderly
as a dentist's office, hostas and liriope
I think they cut from magazines. There is
no smell here, no scent to bury your

nose and drink deep, inhale, suck it all
in, wishing you were a dog so you could
have it all layer by layer, burrowing down
to the smell of earthworms and the garlic

of last year's compost. I will buy marigolds
and crown imperial, dragon arum and the buttery
cones of skunk cabbage, such things as give off
a scent more muscular than roses. I will

import the fly-snapping arum of Sardinia,
also known as the dead-horse arum, although not
the corpse flower, *amorphophallus titanum*,
a giant shaft lifting from a skirt of red

petals, too much scent and metaphor
for this urban space. I will be content
with manageable odors, small but smelly
pushing through the ground, saying it over

and over until I believe it: we are
here, we are here, we are here.

Amanda Cockrell

Home

A moon-bright field raises hairs on the arms.
Wrists go numb remembering dark brooks.
Horses become instinct, thirst.

What it can no longer return to
in the old way, the body rebuilds, reclaims
as if to say: there was always only *here*.

Is this wholeness at last?
The translation of all loved things
to their essence

The barn less brick than silence
that agreed for a time
to gather itself into manger and beam

Jocelyn Heaney

Cutting Liriope*

I hack liriope with the ancient sickle, swooping
from inside out in downward dive and upward
flight. From three clumps of monkey grass dug
up years ago, dozens grow, thrusting deep into
the ground, burrowing like rabbits, birthing blades
beneath the brown. Not transplanting, not maintaining,
I'm barely containing.

Why the sickle? a neighbor asks, *mower's the way
to go, faster, cleaner, easier on the back.* Why the
sickle? I ask myself, pain shooting through my thumb,
hurt darting down my hip, aches sprouting every day,
mushrooms in a human field.

The mower announces itself but the sickle is silent,
moving with certainty across the tough dead fronds,
cutting them off, lopped to earth, making way for tender
shoots crawling toward the sky.

The sickle's from my father-in-law, veteran of the long
Great War, a tool as old as he, who lived to be a hundred-
four. When I take it from its hook, I see him in the garden
where he toiled, full head of pure white hair, a smile upon
his face. He leads me into paradise, strokes his corn, his
beans, tomatoes—juicy and sweet—not like those from
markets on the street.

He winks at me and hums a tune,
I bend down, resume my work,
strike clean across a swath of green.
Beneath the earth the old man laughs
and in my hand his sickle sings.

Esther Johnson

* (lir-RYE-oh-pee) genus of low, grass-like plants used in landscaping

An Autumn Memory

A crisp clear blue sky overhead,
The water still and clear below,
Trees dressed in their autumnal coats,
Birds sing, and, somewhere, caws a crow.

Mountains stand tall and menacing,
Casting their shadows on this scene,
In the distance a train goes past,
The grass glistens in shades of green.

Autumn leaves on a bonfire burn,
Sending out their musty perfume,
On the water there is drifting,
Smoke, like haze, in evening gloom.

Sun then hides behind the mountains,
Nature's colours all change their hue,
Everything has lost its shadow,
Sky is no longer clear and blue,

Pinks and reds become the colours,
Through the sky and water below,
The darkness is fast approaching,
All now has a wonderful glow.

Soon night will throw her velvet cloak,
Over all this wondrous view,
The stars will shine like fairy lights,
And moon will glow and sparkle too.

Then when morning star has faded,
The sun will come back out to play.
The sights of autumn will return,
We will have another new day.

Freda Brodie

Blueridge Bonzai, *Fred First*

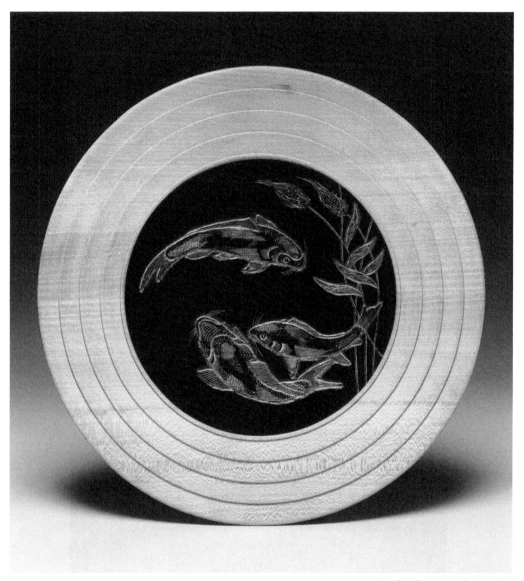

Fish Plate, *Brad Warstler*

Eat

HAVE
this:
your
soft
belly,
the eyes
,little,
that have
given home
to ledges
and held the
wind. Be ugly,
little spirit.
Eat the worm...
Eat. I'd like to
have it and Terra
Cotta coat too...
pull the moss from
a tree. To build
for you, to climb
sky wire and tread
from rock to berry.
I have you. I have
stone. But I have
wanted to wriggle in the
chirping snagging my beak,
I've had a dream... blazing
You are there each time. Now
Hold me, spirit. Eat the light bugs, have the lifeblood
and feel the movement over your worm tongue, warm mouth.
The crack of your fire like a phoenix, being born and
born again. The refracting light hugging your head
and carrying it away. I imagine somewhere far south
like Mexico. You'll see farmers, clay, and Gulf.
You'll vanish there for years, leaving breaths
full of ash. That's why there's dust on fruit
and children, and why I will spend a dozen
days tracing through Chichen Itza with
fire fingers. In the dream, I conquer,
I heal, I church like a Nun. I watch
from El Caracol to see your body,
creased and broken, a lizard
scale, a flint, ninety-year
body. Spirit, tell me...
you have eaten the worm,
fattened your feather.
I do burn the woods
to build cities.
Grab bricks
with talon hands.
Lay them row by row.
Do not fly yet. Do not, Spirit`

Do
not
hold
this:
a bone
picked
off a man
by vulture
mouth. It is
dark on the
marrow and
fire cartilage,
moss along the
length. Bones
like adobe bricks
snapping unsteadily.
Spirit, I have gotten
one away for you. I
have used it to dig
up worms for other
birds. Spirit, I have
twigs and feel the
like a fish, spirit.
like a forest fire...
ignite. Do not fly yet.

Do I've needed to save Spirit
Not you this satchel of Spirit
Fly insects, scathed like Have
Do the desert that protects This
Not you from man, angry and dust. Spirit
Fly yet Rays of sun leaf through branch Have
Do not and capture the line of your jaw. Spirit
Fly I tell you, it is frail before fire. This
Yet The worm will crunch before it dies Have
Do into ugly specks of sinew and flesh. Spirit
Not Your eyes, I fear, I've dreamt Spirit Do
Fly were beetles, beetle skeleton, Have
Do slipping away to the hand of This
Fly a Maya ghost, becoming Spirit
Do sick and blind and Do
Not extinguished.
Yet Eat,
Fly S D
Yet P O
Not I T
Yet R H
 I I
 T S

Bayleigh Fraizer

The Abalone Dive

 Men swathed in scuba suits slice the blue, a cold sun reflected
on the surface ripples interrupted.

These are rocks that crack open to flesh. Sells for a good price
at the fish market, but to pluck more than three is punishable by fine.

Below the surface, the men still uproot them. The more hesitation,
the more they cling. Rip quick from the face so they quiver
in the hand.

The children on the shore slip blades between. Shucking,
rinsing, sneaking tastes of flesh. The water is clear here. Clear enough
to see their toes, the stones, the little fish darting.

They slice them open.
Gut them, and hide them.

Esther Yun

Sanibel Osprey, *Andrew Giovino*

From Interstate 81

Orion's up and faces the half-full moon. Headlights follow the blacktop, turn, brake, merge, sweep, fall short of the sky, reach far enough to tell me where deer might be, are swallowed up in the dark beyond.

Orion follows me. The stars crowd him, patterns turned over and upside-down, Seven Sisters, Andromeda, Cassiopeia, Ursa Minor, Ursa Major. They are not as distant as they will be when the winter is winter and the air is cold.

Between the cities, the dark deepens. Where there were fields, there is nothing; where there were rivers, there are sudden glints of silver; where there were trees, there are tall figures standing silent; where there were mountains, there is a massive blackness carved out against the sky.

The moon tumbles in the creeks. The moon shines off the roofs of barns. The moon casts shadows on the grass. The moon races with the traffic. The moon glows on Purgatory Mountain. The moon spills down the steps from my upstairs window. The moon tangles itself in the walnut tree. The moon rises red out of the ocean. The moon hangs above the city on invisible string. The moon illuminates the trucks stopped for sleep. The moon finds the army tank, gunless, on its flatbed. The moon wakes up a bird that thinks it's morning. The moon turns the clouds into corridors.

Cara Ellen Modisett

The road-trip that was
supposed to save our marriage

The forecast was right about the storm.

We were promised rain, which fell soon enough,

Into broken diamond puddles
sparkling by the gas-pump light.

Stale love songs from years ago
hiss and pop from the ruptured
tin can speakers under the eaves.

The last two hot dogs on the rotisserie
are crusted so dry they wobble like drunks

trying to hold each other upright.

A missing child on a flyer taped to the soda machine,

the paper tear-stained by splashes,

offers a reward for any information.

I pumped the gas. You tried to decipher the map.

Cars full of families sped by on their way to somewhere else.

Dave Wiseman

Birch Trees, *Sharon Mirtaheri*

Patchwork

Late in our marriage I built a room,
Piecing it from fitted boards to cover up
The walls of a porch beginning to lean.
Though slightly slant and often hotter
Or colder than we'd have liked,
It made into a pretty place, surfaced
With textured grain and an elegant finish,
Cosy like a small boat's cabin.

It suited our needs in a house grown old,
A dwelling where we learned which doors
Would stick without warning, which windows,
Increasingly opaque, offered distorted views.
I'd become skilled at papering over cracks,
Restoring the face of conditions gone wrong,
Hiding ills beyond repair that lay beneath.

My father had shown me how to fix a house.
He led by example; as a boy I carried boards
And held down the measuring tape
While he sawed and pounded and cursed.
His techniques were his own invention
And I learned the heart of his philosophy:
That nothing acquired is ever easily let go,
That we are well served by patching over,
That we must make it up as we go along.

James Broschart

Life Dances

It begins to rain erratic slow drops.
The crawling chartreuse sweet potato vine,
erect polka dot plant,
and fledgling rose's leaves
curtsey as a single water drop
hits a leaf note.

Trees sway in dance.
Squirrels are doing nooky things
in the treetops.
In a Capella one cicada,
legs to wings, fills the air
with raspy shrieks;
an act of self actualization.
Plink, plonk, tong, ting;
the leaves sing.
Base notes of distant thunder.

Contented dusk arrives.
The meat of the storm moves around us
aborting the song.

Sharon Mirtaheri

Guinea Mama

From each window the shrill peep peep
as I go about my tasks.
How can the guinea mama continue
looping through the field oblivious
to this week old chick lost where
meadow sharks might strike
nab the bright orange diminutive feet
or sky snakes drop from limb
to suffocate the fuzzy babe.
Oh, what anguish in the cry of number five
while from the garden mother squats.
I've heard as mothers, guineas
rank worst in all the fowl world;
but, truthfully, their lives being as they are,
with predators afoot and in the air,
the lessons must be harsh
to imprint every polka dot of their flighty heads.

Mary North

Devil's Marble Yard

Take the gravel tract away from Cave Mountain Lake.
After the last house and the National Forest sign,
you'll see a worn pull-over place to park.

In early spring, spotted trout lilies line the path
to the trail marker. Pick your way
along uneven footing through stones and rocks

where two native lovers, from enemy tribes, crept.
You'll see the face of a limestone mountain.
Chunks and chunks of this white sandstone fell

on top of the Indian lovers after they leapt.
If you climb into the middle of the marble yard,
it's possible to imagine the silence we'll enjoy

when warring stops.

Molly O'Dell

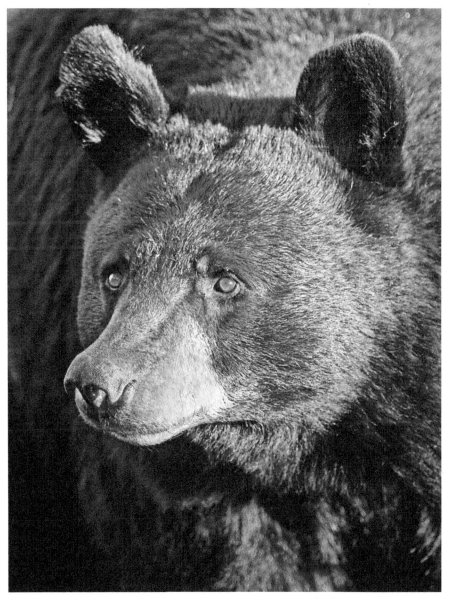

Black Bear, *Dusty Wallace*

Natural Details III, *Sherrye Lantz*

Riker's Island*

On Rikers Island a
sloping field is set
aside for cremated
remains of those poor
and banished.

Who perish
without the
cost of a funeral,
without provision
of mourning.

It is here
the poorest
of poor are
buried. Where
there is no coin.

Simplicity of
wildflowers
adorns this
somber
paradise.

Here
sleeps a
newborn child
never touched
or held.

His cry
was a voice
unheard; rain in
the eye of a
ruined flower.

Queen Anne's
lace, royal
and proud in
its grief stands
upright.

His birth
was a red
poppy that
shredded and
burned.

His death a first
tragedy given to
his mother. A first
cycle through a
season of fire.

The mother knew
his promise was only
of sorrow. Memory
cremated into bone
and bleached.

Sad purity of
infants that starve
and die before they
open cornflower
eyes.

Poverty
so primal
and unselective
devours people
& countries.

Poverty
belongs as
much to earth
as bone and
wheat.

Sorrow lives on
Rikers Island,
with the first and
most tender ash
given to earth.

Diane Dehler

**Riker's Island is a public
cemetery in New York where
inmates and the destitute
of the city are buried.*

My African Mother

I remember something there's no way I should.

A wide river, me on the shoreline,
Paradise, Eden.
Even now I'll sit entranced
By the worst movie about Africa.

I remember my mother,
Her deep strength and beauty.
Every time I'm cold I remember
The warmth in every direction.
Every time I'm alone
I remember that we are the people.

I have no business remembering this.
But the poet's ribbon is wide,
Wider than water, bendy as any river.

2.
When I shallow from things
I think to myself of Africa.

My mother's name is Eve.
I am her ambassador
To the ends of the strange world.

I look for lost paradise
In the sudden Snake Canyon.
How can I throw a rope across?

It's easy.

When my hair grows out
It curls and ties me back to her,
To the tight deep curls of her dark hair,
To the ribbons of the banks of the Nile.

Mark Fogarty

[hello empty wednesday]

the fox jumped over the dead dog
the mailbox stood and watched

two mouths in a moment
gaping open without fishhooks

but with headlights shining like spotlights
overhead like floodlights, they illuminated
the dewy cobwebs inside the box and

the rearview mirror
saw the dog's leg twitch:

hello empty wednesday.

raven casey

Apologia

The beauty of death may be how
it separates pain from the body.

The body, then,
made of so much pain,
needs our sympathy.

Just as we sing of spirit and light,
pray to symbols,
and dream of being free
of nerves and strain,
shaking hands and cough,

perhaps we can also try to listen,
make out of each pang and scar
scripture,

read the lines worked into the skin
as the body's
apology for
working against its nature,

a tree bowing
over time
to the ground.

Jose Angel Araguz

Surreal Mists, *Joan Laguzza*

Overhead, Brain-Kill Buzz.
Poet Views Out

across broad valley. Route 220 rivers below: ghost
 orchard, biz park, *pestilence-stricken* truck [*Let this seed*]
 stop's [—Vandana
 Shiva—be exhaust
-*less.*] junk. In holler no longer [and yet, thinks poet, why]
 pasture, [brood, when after] drive-thru bank branch
 squats. A kettle
 of hawks curves

south. Pylons stalk [all] over Tinker Mountain, [spring
 comes and] radiants from Cloverdale, where coal
 -fired power [I
 use] steps steely
down. Their straight trails drone, dividing [only a little
 juice, and hey,] tree-sea's October usual. Oaks
 exhale [I walked]
 their red last [up

here.] Cloud-line runs low this side of Purgatory's
 ridge. That *autumnal* trace, the James. Beyond
 [The gobi-colored
 smudge horizon
-far arising?] lies [O paper] Covington, where,
 [mill town.] winters, waste-flakes fall *pale*.
 [Our common air
 for] Belly like *black*

dump-land] *rain* burns [seized.] and *gray with fear*,
 poet observes 1 moving *yellow* ash. [Limb
 gone, it—*auto*
 -*poetic*—heals.]
Pulls notebook out. A page in *west wind* rattles,
 lone dry leaf. [No, wood-pulp, and what earthly
 good another buzz
 -kill *thorns…I*

bleed! to flurry with *grave prophecy,* with *hectic*
 multitudes ?] Shrugging, poet [Air] invokes. [chants
 the *skiey*] Writes:
 you [ode.]who
see yet cancerous live, snatch this balm. [This
 laudanum,] You, maker, [this breath's]
 destroyer, dendritic
 [narcosis.] *lyre*.

Jeanne Larsen

I Brought Back
A Small White Stone

From Emily Dickinson's home In Amherst

And on my walk tonight
Tapped different things
Across the city of Huntington

Seeking
Not just the meaning
But textures
In the sounds of words

Especially in orange twilight
Against brick Click your teeth
Lamp pole Crack your knuckles
Porch wood & tree bark Burp
Stop sign Snap your fingers

What hollow noise
Will sound bouncing off
The new sheriff's
Brand new Cadillac Allante
Sixty thousand for airbags

Emily Protect me from all desire for wealth

John McKernan

Tree wise
(Castanea dentata)

Woods wandering
early spring
trout lily time
A rotten stump
mosscovered
halfhidden by windblown leaves
Look close
at how new green shoots
sprout rakishly
from blighted wood
From death, life
But life is fleeting;
the virulent fungus
lies waiting
ready to girdle the tree
in it's own time
as it has already done
so many times
before.
Inevitable.
Why does the tree bother?
Is it without knowledge?
Without memory?
Without care?
Is it blind defiance?
I'd like to think
It's a stump accepting
Knowing full well what darkness awaits
Yet rising to meet it
Anyway

Tim Miller

Natural Aesthetics

Copper Egg is a "sculpture", an object freed from utilitarian purpose and yet imbued with importance relative to it's aesthetic or conceptual value.

It is a human effort to create beauty with reference to "natural" aesthetics, to create an object with tactile and visual appeal. The effort to create this appeal speaks to the criteria we use, either consciously or subconsciously, to evaluate which aspects of nature we admire in a similar way to "art".

Why do certain stones, or pieces of driftwood find their way home with us, while others remain in their resting place, deemed aesthetically inferior? On one hand this question is naively simple, but on another, the implications of how we impose human values to ascribe worth or lack thereof to "nature" are profound.

Chris Hill

Copper Egg, *Chris Hill*

What Our Eyes Miss

First I see the goldfinch,
their feathers getting yellower each day
It's been a long winter,
almost April
and still three feet of snow

Between the still bare branches
a purple finch perches,
eyes darting back and forth.

I take my mother's hand,
pull her up to watch the flutter
going on between feeders

when splash,
a frantic scramble on the snow,
like ink spilled on paper
or birds ensnared in sudden tantrums.
I cannot make it out.

Then whoosh,
gone,
quick as that,
the grackle,
tiny now,
tucked up against the belly of the hawk,
against a firmament of gray

Predator took prey
right before our eyes,
leaving us dumbfounded,
leaving us four black feathers on the snow.

Frances Curtis Barnhart

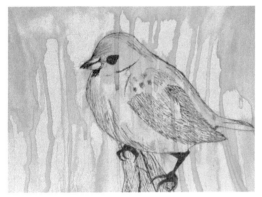

Bird in the rain, *Krista Graham*

Revived by Strangeness

Estuary is the mouth, the jaw that guides,
welcomes us to a new world.
Humidity, a sponge sucks our boat in.
We come willingly. Here there are crocodiles,
teeth hiding in the shade.

River is the throat. Mangroves
dance above water on tall roots.
Their tannin turns the water copper.
Twisted branches guide us deeper in jade darkness—
we come wide eyed, stunned.
Canopy's dome grabs sunlight from our eyes.
Cicadas' shrieks call us on.

Forest is the stomach that takes us oddly.
We walk gladly on mud, slippery flesh.
Everything throbs with light rain and breeze.
Orioles gurgle and trill. Healthy lump
thrives on a tree trunk- cacao bean,
food of gods, people, sloths.

Forest is the stomach that takes us oddly.
We walk gladly on mud, slippery flesh.
Everything throbs with light rain and breeze.
Orioles gurgle and trill. Healthy lump
thrives on a tree trunk- cacao bean,
food of gods, people, sloths.

Bat cave is the center, the heart.
Knee deep in water, we laugh and slip on rocks,
slime. Last glow from the sun
vanishes, taken by stalagmites.
Echoes throb through this drum's inner world.
Bats, slices of night dangling from rough walls,
turn their faces to us. They drop,
zip past our cheeks, kiss us with their wings' breath.
They rule this night place, let us pass.
Their guano smells like distant skunk.
When we leave, forest greets us with thunder.

Isla de Bastimentos, Panama 7/12
Paul Belz

New Mexico Sea

Hot
pueblo roads, adobe brick
crashing two
warm bodies into sun, there was no
trace
of ocean there. No trace
of vast, seaworn volcanoes
sending ripples up
and out,
only
smooth rocks
perfect for touching, for
learning the
names of, for grabbing onto the
easy material existence
of them. No threat
of deep
undercurrents.
There are no
riptides
in New Mexico
anymore—500 million years
since any shallow sea
complicated
the foundation, and centuries since
the last Apache chief put down
his head

and his pipe
one final time—no,
there are only slow moving
desert tortoises
who survive by knowing when
to turn
themselves
into perfect shelter, their armory
my currency
here,
and coyotes who
know how to
celebrate
a kill.
So when he grabbed
the easy
material existence
of me, it was like by a man
incapable of
drowning,
the dry desert air
impatient
to forget
salt. And I did not fear for
losing

myself, I was too far from
the Pacific.
Reflections in the road
are mirages you don't have
to worry
about and lovers only die of
starvation
here. Luckily, I was full of eating sand,
I had bloated into
a heavyweight
version
of myself, a contoured container
like sandbags for
the dunes,
made of wind but separate and
packed tight
to keep
distant waves from pummeling
the face
of the shore. I could not be swept
away, and so when
the smooth polished stone of his body
skipped over me,
finally
I did not feel
I was being
pulled under.

Nancy Lynee Woo

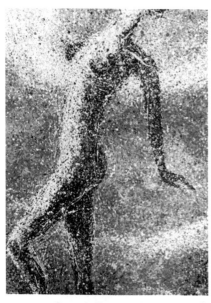

Cosmic Dancer, *Mimi McHale*

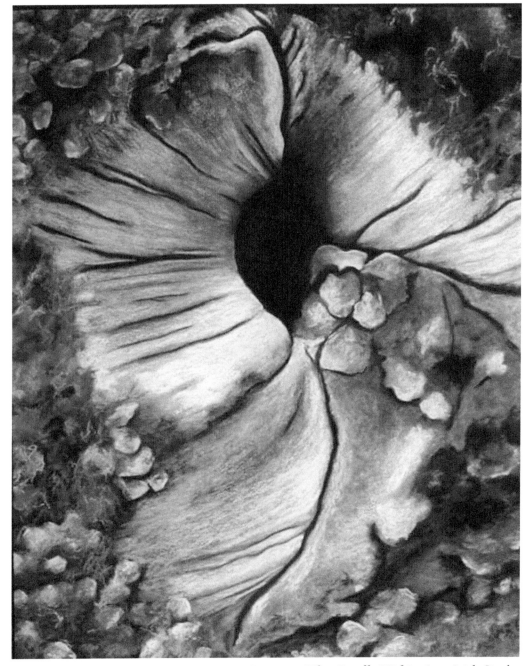

Divine Doorway, What Dwells Within, *Lora Leigh Giessler*

Convergence

*We are here to awaken from the
illusion of our separateness.*

> *~Thich Nhat Hanh*

Where the light passes, the shadow
is not revealed, but dispelled—
calla towers in the petal
of cliff, detail of movement
enlarged in stillness.

Silence widens
brush, figures in sand, hand
of stone, folds of edge.

Howl in the background, falling
ribbon, shells, signs. Birchbark
peeling out of sight, last night
when the stars
were stars, your fingers.
This frame.

Where the shadow passes, the climb.
Baskets lean on the shoulder.
We come together, burden
and carrier, length
of the length of gather.

Mara Eve Robbins

A Letter

In the time of famine,
when corn came bitter,
grapes dried on the vine,
and cotton wept in bolls;
In the time of famine,
when pleasure drained from the deserted sand,
bass boats lay alone on the dead grass,
and piers peered out at the retreating reservoir;
In the time of famine,
when goats licked fragments of weeds from the dirt,
rib-caged dogs lapped traces of urine from the pavement,
and deer panted beside the dry brook;
In the time of famine,
when earth cracked under the mocking sun,
broken skin bled tears like pearls around grains of dust,
and lovers tenderly touched the scales of their lips;
In the time of famine,
when God shriveled into a question,
the cloudless horizon condemned,
and the viper warmed to its nature;

In the time of famine
your words arrived from afar,
figs out of season;
they struck like a staff upon a rock,
surely the spring must follow;
they brought memory of lilacs
and promised an angel bearing a vessel at dusk;
they were a single chilled plum
already half-savored in my mouth;
they were balm spread by your hand
over my devouring body,
oh so sweet,
oh so succulent,
and oh so fleeting
in the time of famine.

Charles Katz

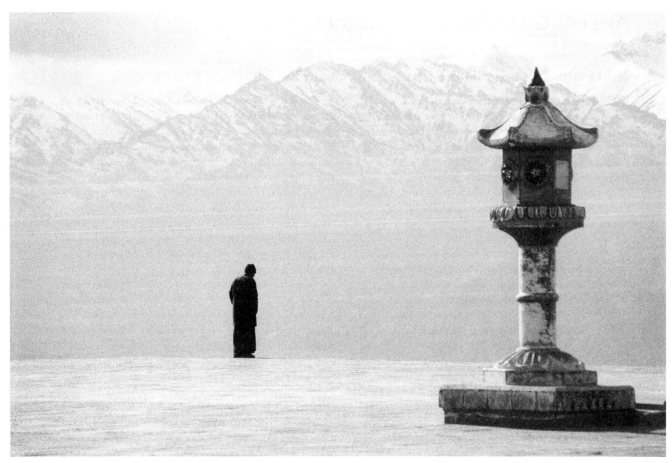

Monk, *Jackson Rogers*

Artemis Guest Poet and Photographer

Nikki Giovani, *Guest Poet*

Nikki Giovanni, poet, activist, mother and professor is seven-time NAACP Image award winner and the first recipient of the Rosa Parks Woman of Courage Award, and holds the Langston Hughes Medal for Outstanding Poetry, among many other honors. The author of twenty-eight books and a Grammy nominee for *The Nikki Giovanni Poetry Collection*, she is a distinguished Professor of English at Virginia Tech in Blacksburg, Virginia.

"The work of Nikki Giovanni has been as evolutionary as it has been revolutionary. One of the finest poets of our time..... Her work still resonates."
~Ebony Magazine

"Nikki Giovanni is as outspoken, prolific and energetic as ever."
~New York Times

"Nikki Giovanni is the soothsayer for the new millennium. Her words are filled with precise insight, wit, and free love. Her poems are a balm for wounded souls. The sister is still baaad. I mean she can fly like a bird in the sky."
~Bebe Moore Campbell

"Wise and mischievous, Giovanni is a must read at every stage of her happily still growing oeuvre."
~Booklist

"Nikki Giovanni is one of our national treasures. For decades she has offered her wit and wisdom, her bruising honesty, and above all, her unbounded love through....poems as a healing for herself, her community, and her country."
~Gloria Naylor

Sam Krisch, *Guest Photographer*

Sam Krisch is a Roanoke-based fine art photographer known for his dramatic landscapes and iPhone photography. His work has been exhibited throughout the United States and he is Adjunct Curator for Photography at the Taubman Museum of Art. Sam shares these thoughts about his photography and his pieces printed in *Artemis*:

I have had the great fortune to travel in search of magical images. The last five years I've journeyed on five continents and to about fifteen countries. At first, I started my travel for a writing project, then as I picked up a digital camera, images flowed more naturally than words and I began seeking out unique places. I found the most captivating images were the large moody, atmospheric landscapes. I am particularly drawn to the sculptural, crystalline feel of ice, the quiet drama of the desert, the energy and isolation of the sea, and the life of the land. I pursue more than the classic, iconic scenes. I want work that challenges me physically, technically, and psychologically to capture moments that are unique.

*The land and sea scapes published in **Artemis** are typical of my style. **Sunrise, Antarctica** (page viii) was captured from the deck of a ship on a morning when the light was dancing on the water's surface and the clouds became apertures through which bands of streaming light highlighted parts of the frozen mountain. **Passages V** (cover) was captured on the Drake Passage between Argentina and Antarctica. It was a day of relative calm and sunshine and I was able to capture some of the dramatic power of the sea on deck.*

*I do have an altar ego. I am also an iPhone photographer. I followed friends of mine into "iPhoneography" in 2010 and have been obsessed ever since. The iPhone image **Picnic** (page 3) was captured in 2011. The model, a dance student, has a classic look that fits my iPhone aesthetic perfectly.*

Artemis Contributors

Adams, Chelsea: *Dwelling Place*
Chelsea lives on five wooded acres in Riner, Virginia. Her chapbook, *At Last Light*, was published in 2012 by Finishing Line Press. Her poems have appeared in numerous journals including *Albany Review, Rhino and The Southwestern Review*.

Alderson, Curt: *Thistledown*
Curt Alderson lives with his wife and two sons on a family farm in southwest Virginia. He holds a master's degree in english from Radford University. His work has appeared in various publications including *Red Crow, Aura Literary Arts Review, The Fertile Source*, and *Spoken War*.

Allen, Mike: *A Curtain of Stars*
By day, Mike Allen writes the arts columns for *The Roanoke Times*. By night is novelist, editor, publisher, and poet. His wife, Anita, is an artist and horticulturist, as well as his co-editor on many projects.

Araguz, Jose: *Apologia*
Jose Angel Araguz has had work most recently in *Barrow Street, Gulf Coast, Slipstream*, and *Right Hand Pointing*. He is presently pursuing a PhD in Creative Writing at the University of Cincinnati.

Ayyildiz, Judy Light: *Signs*
An internationally published author-educator with ten books in five genres and a new volume of poetry forthcoming in fall 2014, Judy was an *Artemis* editor for thirteen years, and a Blue Ridge Writers Conference founder. She can be found at judylightayyildiz.com.

Barker, Lucile: *Ice Storm*
Lucile Barker is a Toronto poet, writer and activist. Since 1994, she has been the co-ordinator of the Joy of Writing, a weekly poetry and fiction workshop at the Ralph Thornton Centre.

Barnhart, Francis Curtis: *What Our Eyes Miss*
Frances Curtis Barnhart is the author of *The New Woman Warrior's Handbook: Not for Women Only*, published by Illuminated Way Press under her former name Marjorie Curtis. Barnhart has had over thirty years of experience teaching, practicing literary and visual arts, and exploring spirituality. She was ordained in 2004 as an Inter-Spiritual Minister by The New Seminary in New York City.

Betz, Paul: *Revived by Strangeness*
Paul is a writer and environmental educator currently based in Oakland, California. his poetry has appeared in a range of small presses and websites, and his articles on travel and environmental education appear in *Childcare Exchange Magazine, Terrain Magazine, The East Bay Monthly*, and website *Boots'n'All*.

Bidwell, Susan: *Pandora's Friend*
Before receiving a formal education in photography, Susan was taught black and white photographic processing by fellow members of the *Alice Springs Camera Club* in Australia. Since returning to the United States, her artwork has won numerous awards and is held in public and private collections. She is a member of *The Market Gallery* in Roanoke, Virginia.

Boissonneault, Karen: *Redwood Knot*
Writer and photographer Karen Boissonneault-Gauthier's works have been published in national and regional papers, literary and vocational journals as well as heritage museums. Never without her camera, she likes to find the unusual within the mundane and ordinary.

Artemis Contributors

Bowlin, Diane Dee: *Walking Stick Left for the Next Hiker*

Dee's award-winning poetry has been published in *Encore, Golden Words,* and *Virginia Literary Journal.* Her song lyrics have been put to music and performed on stage. She was honored as the 2011 Poetry Society of Oklahoma Poet Laureate and accepted into *The National League of American Pen Women* in 2012.

Brodie, Freda: *An Autumn Memory*

Freda Brodie is a 58-year-old pagan mother of five and grandmother of seven. Born and raised in Scotland, she currently resides in Merseyside, England, and has been writing poetry since 1996.

Broschart, James: *Patchwork*

James Broschart has retired from several occupations including classroom teaching, bookstore management, technical writing, and public television. In the face of such widely varying points-of-view, he believes that writing poetry serves to keep him centered.

Burkholder, Brad: *The Hermit*

Brad Burkholder and his wife live on a farm in Bedford County, Virginia. In addition to being an English professor at Virginia Western Community College, he has published in numerous journals over the years.

Carpenter, Michele Rice: *Almost Done*

Michele Rice Carpenter is a writer/photographer who lives in Check, Virginia. She loves gardening and spending time with family, friends, and pets. Her photos, poems, and stories have appeared in *Floyd County Moonshine.* She founded the Floyd Writers Group.

Casey, Raven: *[hello empty wednesday]*

Raven Casey is twenty years old and lives in Kent, Connecticut, where the Appalachian Trail is her backyard. She attends Mount Holyoke College where she studies French and Education, but weaves poetry into her curriculum as much as possible.

Cockrell, Amanda: *Crown Imperial*

Amanda Cockrell teaches creative writing and is director of the Graduate Programs in Children's Literature at Hollins University, where she is also editor of *Children's Literature,* and managing editor of *The Hollins Critic.* Her most recent book is a young adult novel *What We Keep Is Not Always What Will Stay* (Flux 2011).

Dehler, Diane: *Riker's Island*

Diane Dehler has been nominated for the Pushcart Prize 2014. She received a degree from the Creative Writing Program at San Francisco State University and is published in several journals.

First, Fred: *Blueridge Bonzai*

Fred First is a writer, photographer, speaker and biology-watcher who frames his personal ecology in words and images from Floyd County, Virginia. His writing and photography center on relationships to nature, place and community. Since 2002, he writes and posts images regularly at fragmentsfromfloyd.com

Fletcher, Arleen: *Sunrise: Cades Cove*

Aileen has a BA from Duke University and an MA from Virginia Tech. She taught art at New river Community College for 33 years, retiring in 2011. She has been interested in art all her life and concentrates on photography as her major artistic pursuit.

Fogarty, Mark: *My African Mother*
Mark Fogarty is a poet, musician and journalist from Rutherford, New Jersey. He is managing editor of *The Rutherford Red Wheelbarrow* and emcees their monthly music-poetry reading. He has been published in *Hawaii Review, Viet Nam Generation, Exit 13, Footwork, Eclectic Literary Forum*, and others. He is the author of three books of poetry.

Fraser, Bayleigh: *Eat*
Bayleigh Fraser is an American poet currently residing in Canada. She studied English at Stetson University and has appeared in various publications including *A Bad Penny Review, Motley Press, The Lake, The Social Poet* and a forthcoming chapbook, *Sounds of Home.*

Gabrielle, Jane: *The Dungeon*
Jane Gabrielle is a writer, visual, performing and recording artist, and owner of One World Arts, a live entertainment company. She tours the southeast united states with Midway companies as a face and body artist and also paints for Royal Caribbean. She sings solo and with folk rockers Radar Rose.

Giessler, Lora: *Divine Doorway: What Dwells Within*
Lora Leigh is an artist, art educator and massage therapist currently living in Tucson, Arizona, but deeply rooted in Floyd, Virginia. She is a student at the Tamalpa Institute in California studying a movement and art based therapeutic modality developed by Daria and Anna Halprin.

Giovino, Andrew: *Sanibel Osprey*
Andrew will be a high school student this fall, and has a strong interest in photography. Before receiving his first digital SLR camera last year, he published his ipod photos on Instagram to a sizable group of "followers". He learned basics from a pro photographer and takes photos in his neighborhood and on family trips.

Goette, Ann: *Territory*
Ann Goethe's novel, *Midnight Lemonade*, was a finalist for the Barnes and Noble "Discovery Prize." She is a published playwright and her poems, essays and short stories have appeared in numerous journals and magazines. Goethe is a member of the performance group "Loose Threads", and is the founder of the Blacksburg New School. She lives on the New River in Eggleston, Virginia.

Goette, Jane: *Honeycomb*
Jane Goette has been a teacher and a writer since moving to Blacksburg in 1977. In 2004, she was a Resident Fellow at the Virginia Center for the Creative Arts. She was a member of the Virginia Wolves writer's group for seventeen years. Jane has published poems and essays and is completing a memoir about growing up on Louisiana's historic River Road during the last days of segregation.

Goepel, Gwen: *Nature's Palette*
Gwen Goepel has created art since childhood. After graduating from Bucknell University in 1976 with a BA in Art, Gwen pursued her fiber arts. She participates in regional and international art quilt groups and quilts daily.

Goff, Diane Porter: *Return*
Diane's poetry and short stories have been published in *The Sun, Southern Distinctions* and most recently, *Hospital Drive.* She has a Masters from Hollins University and her memoir, *Riding the Elephant: an Alzheimer's Journey,* was published in 2009 by Dreamsplice Press. Recent work was showcased in "Loose Threads".

Artemis Contributors

Gowdy, Margie: *Marigolds*
Margie Gowdie is a grant writer and ran a small art museum for many years. She raised three children but lost one. As she nears retirement, she is beginning to write for herself with natural surroundings as an inspiration.

Graham, Krista: *Bird in the Rain*
Krista Graham was born in Central Kentucky in 1988. At the age of six she wanted to be Van Gogh. Making art is among her happiest moments. But, more than creating it, she loves to share her art.

Granatelli, Silvie: *Crane Ewer*
Silvie is a studio potter working in Floyd, Virginia. She was the recipient of the Virginia Museum Fellowship Grant and her work has been featured in private collections, the Taubman Museum of Art, The Museum of Ceramic Art, the Mint Museum, and many publications. She teaches in New Delhi, India, Tuscany, Italy, Izmir, Turkey and Universities throughout the United States.

Hagy, Al: *A Crow Watches*
Al is native of Tazewell, Virginia. He studied at Lynchburg College and the Medical College of Virginia. For more than 50 years he has been a "country doctor," and physician educator for Roanoke Memorial Hospital, the Carilion Health System, and the University of Virginia School of Medicine. He practices Geriatric medicine and is a fledgling poet.

Heaney, Jocelyn: *Home*
Jocelyn Heaney holds an MFA from the University of Massachusetts, Amherst. Her work has appeared in *The Los Angeles Review of Books*, and she blogs about writing and nature at sharkdreams.net.

Henderson, Dan: *Summer Solistic*
Dan is as an "old-school" photographer who uses fifty year old cameras and large format black and white film to make photographs. He enjoys the methodical process of creating a good composition and exposing the film properly. His photographs can be seen at The Market Gallery in Roanoke or at danhendersonphotographer.com

Hill, Chris: *Copper Egg*
Chris Hill attended the San Francisco Art Institute, Graduating with a BFA in sculpture in 2000. His work has been exhibited in the 2005 "Stick to Your Guns" group show in Roanoke, and also in a 2006 solo show at the Walker Gallery, Patrick Henry Community College. Chris lives in Floyd, Virginia, and also pursues an interest in Chinese medicine and martial arts.

Hill, Mary Crockett: *Pantoum for Attachment*
Mary Crockett coauthored a young adult novel, *Dream Boy*. Her most recent book of poems, *A Theory of Everything*, won the Autumn House Award. She also writes a blog at marycrockett.com and can be found at pretty much any coffee shop in southwest Virginia.

Hillhouse, Joanne: *Civ-i-li-za-tion*
Joanne C. Hillhouse is the author of many stories and *Oh Gad!*, her first full length novel. She's also been published in several international journals and anthologies. Joanne lives in Antigua, and from there freelances across borders as a writer, editor, and writing coach.

Holmes, Jordan: *California*
Jordan Holmes is a poet, music artist, and senior at Virginia Tech, majoring in Materials Science and

Engineering with a minor in Green Engineering. He is involved in *VT Expressions*, and helped organize Virginia Tech's Inaugural Poetry Slam. He is starting See Thru Vision, an entertainment company to showcase artistic talent.

Johnson, Esther: *Cutting Liriope*

Esther Whitman Johnson is a former Roanoke County educator who now volunteers on five continents and recently completed her 12th international build with Habitat for Humanity in Mongolia. A passionate traveler, she writes poetry and nonfiction, often about her journeys. She lives in Roanoke with her husband and beloved mutt Maddie.

Jonik, Lauren: *Clouded Reflections*

Originally from Pennsylvania, but now based in Brooklyn, New York, Lauren Jonik is a freelance writer and photographer. She currently studies writing at The New School in New York City. Her work can be seen at shootlikeagirlphotography.com

Katz, Charlie: *A Letter*

A long-time Virginia resident, Charlie Katz has spent the last four years chasing his grandson around Roanoke and New River Valley parks. He believes there is poetry in and for everyone. This is his first published poetry since his recovery from juvenility. He lives in Blacksburg with his wife and dog.

Laguzza, Joan: *Surreal Mists*

Joan lives in Fincastle, Virginia and is about to receive her Master's degree from Radford. Born in Los Angeles, and having lived in Paris for many years, Joan is enigmatic and cosmopolitan.

Lantz, Sherrye: *Artemis, Natural Details 111*

Ms. Lantz is a retired studio art and art history professor. Her work can be found throughout the United States and Europe in public and private collections. She has worked in an abstract manner since the early 1980s, with occasional returns to realism. She lives a reclusive life surrounded by her beloved Blue Ridge Mountains.

Larsen, Jeanne: *Overhead, Brain-Kill, Poet Views Out*

Jeanne Larsen's latest book is *Why We Make Gardens (& Other Poems)* from Mayapple Press. She is also the author of four novels, another book of poems, and two books of poem translations. She moved to the Roanoke Valley in 1980, and teaches in the Jackson Center for Creative Writing at Hollins University.

Leggett, Caroline: *Barn at Blue Ridge Institute and Museum*

Caroline was born in Roanoke, Virginia, but also grew up in Arizona. She was recruited into the US Navy, serving six years in both the Pacific and Atlantic Oceans. Caroline believes sometimes it's necessary to travel the world to appreciate home. She loves capturing the beauty of Appalachia people, scenery, and history with her camera.

Levine, Eleanor: *Plath's Boy*

Eleanor Levine's work has appeared in *Fiction, The Evergreen Review, Midway Journal, Pank, Hobart, Artichoke Haircut, Connotations Press, The Coachella Review, Milk Magazine, BLAZEvox, Atticus Review, The Denver Quarterly, The Toronto Quarterly, Monkeybicycle, Lunch Ticket Magazine, Prime Mincer, Happy, Gertrude, Thrice Fiction, Storm Cellar* and others. She received an MFA in Creative Writing at Hollins University in Roanoke, Virginia.

Artemis Contributors

Louthian-Stanley, Gina: *Bent Mountain Marsh*
Gina Louthian-Stanely is a teacher, jewelry maker, printmaker, and writer living in the Blue Ridge Mountains, Virginia. She has been a practicing artist since the 1960's. Her work has been published in articles and books, has received honors and awards, and is in corporate and private collections.

Manuel, Margaret: *Ballad of Frida Kahlo*
Margaret Manuel is an artist, writer, and student nurse at Jefferson College of Health Sciences in Roanoke, Virginia, and an art alumni of Longwood University, Farmville, Virginia. She hopes to incorporate art therapy and holistic nutrition into health care practice.

McHale, Mimi: *Cosmic Dancer*
As a child and young adult, Mimi spent the majority of her life living up in a tree house where she learned to see nature in multi colors. Self taught, she is always experimenting. Her art appears in private collections throughout the United States, Canada, Middle and South America.

McKernan, John: *I Brought Back A Small White Stone*
John McKernan grew up in Omaha, Nebraska, recently retiring after 41 years of teaching at Marshall University. He spends his time editing *ABZ Press* and lives in West Virginia and Florida. He has published poems in many places from *The Atlantic Monthly* to *Zuzu's Petals*.

McKernan, Llewellyn: *The Evening After Work*
Lewellen has published four poetry books: *Short and Simple Annals, Many Waters, Llewellyn McKernan's Greatest Hits,* and *Pencil Memory.* Her poetry has also been published in literary journals: *The Kenyon Review, The Antietam Review, Now&Then, Appalachian Journal, Appalachian Heritage,* and *Southern Poetry Review.*

Michael, Emily K.: *Cello*
Emily K. Michael is a musician, poet, and adjunct writing instructor at the University of North Florida. She teaches entry-level composition courses and grammar workshops for multilingual learners. Her poetry has appeared in *Wordgathering: An Online Journal of Disability Poetry*, and her creative nonfiction has been featured in *Narrative Inquiry in Bioethics*.

Miller, Tim: *Tree wise (Castanea dentata)*
A middle school teacher for fifteen years, Tim is searching ways to teach, learn, and share the outdoors through his "adventure education" business Muddy Squirrel. Tim is an Eagle Scout, mountain biker, trail runner, and ultramarathoner who lives in Virginia's Blue Ridge.

Mirtaheri, Sharon: *Birch Trees, Life Dances*
Graduating from Hollins University with a Master of Arts in Liberal Studies, Sharon studied printmaking and collage. Nature is the primary theme in most of her work and a healing force in her life. She works in encaustic wax, a product of honeybees and an ancient art medium used by many of the master painters.

Mitchell, Felicia: *Revelation at Philpott Lake*
Felicia's poems, if not about family, are grounded in her relationship with nature. She is most at home in the woods of her adopted home of southwest Virginia, which has inspired many poems.

Modisett, Cara Ellen: *From Interstate 81*
Cara Ellen Modisett's essays have appeared in *Still: The Journal, Pine Mountain Sand & Gravel, Braided Brook, Flycatcher, Pluck! Journal of Affrilachian Arts and Culture,* and three books on the Blue Ridge Parkway. She teaches composition and journalism, is an announcer for WVTF public radio, and editor of *Blue Ridge Country* magazine.

Moeckel, Thorpe: *Bridge to Woodall*
Thorpe Moeckel's work has recently appeared in *The Southern Review, Hotel Amerika, Free Verse, Wild Earth,* and *Nantahala.* A manuscript of his was a finalist for the *Field* Book Prize last year.

North, Mary Hayne: *Guinea Mama*
Mary is part of a group of six artists who performed their works "Loose Threads", at Theatre 101 this past summer. She enjoys writing, practicing homeopathy, art, and her grandchildren.

O'Dell, Molly: *Devil's Marble Yard*
Molly was raised in southwest Virginia where she currently lives, writes and practices medicine as the public health director for the New River Health District for the Virginia Department of Health. She received her MFA from the University of Nebraska in 2008. Her poems have appeared in *JAMA, AJN, CHEST, Whitefish Review, Platte Valley Review, Magnolia* and several anthologies.

Pauley, Pauline: *Hours in Early Winter*
Polly Hollar Pauley's poetry has been published in *The Hollins Critic, Cider Press Review* and *The Alleghany Review.* She lives with her husband and two children in Botetourt County, Virginia.

Petrie, Mark: *Auspice*
Mark Petrie's poems have won many awards and have appeared in *Lunch Ticket, Blackheart Magazine, Geist, SNReview, Booth,* and other journals. He spends time between New Orleans and Lafayette, Louisiana, where he is a doctoral student and University Fellow in English Literature/Creative Writing at the University of Louisiana.

Polseno, Donna: *Untitled*
Donna is a studio artist living in Floyd, Virginia, who teaches ceramics at Hollins University and is the creator of the annual symposium "Women Working Clay". She serves as adjunct Curator for Ceramics at the Taubman Museum in Roanoke, Virginia. As a recipient of two National Endowment of the Arts Grants and a Virginia Museum Fellowship, her work is featured in many Publications, private and Museum collections. Donna teaches nationally, including Penland School of Crafts, Long Beach Foundation, and around the world in China, Italy and Turkey.

Prentiss, Sean: *The Lake at Dawn, The First Morning*
Sean is co-editor of a forthcoming anthology on the craft of creative nonfiction. His essays, poems, and stories have appeared in *Brevity, Sycamore Review, Passages North, ISLE, Ascent, River Styx, Spoon River, Nimrod,* and other journals. He has been awarded an Albert J. Colton Fellowship.

Prieto, R. Elena: *Charles Darwin*
R. Elena Prieto is a graduate of the Southern Illinois University Carbondale MFA program. Her work has appeared in *OVS, Moon City Review, Off the Coast,* and in *A Face to Meet the Faces: An Anthology of Contemporary Persona Poetry.*

Artemis Contributors

Redman, Colleen: *The Collector, Winter Sparkler*
Colleen Redman currently writes and provides photography for *The Floyd Press* and other regional publications. Her poetry has appeared in *Mothering* magazine, *We'Moon journal*, in local publications and online. She is author of *The Jim and Dan Stories*, a memoir about her brothers' deaths and writes a blog: looseleafnotes.com.

Rinne, Cindy: *Passions & Tangles*
Cindy Rinne creates art and writes in San Bernardino, California. She is an Editor of *Tin Cannon* by PoetrIE and a Poetry Editor for the *Sand Canyon Review*, Crafton Hills College; California. She won an Honorable Mention in The Rattling Wall Poetry Contest. Cindy is a Guest Author for Saint Julian Press and a a founding member of PoetrIE, a California inland empire writing collective.

Robbins, Mara Eve: *Convergence*
Mara Eve Robbins lives and writes in Floyd County, Virginia, her home since she was eight years old. Her work reflects a community of artists and progressive thinkers placed deep within the beauty of the Blue Ridge Mountain Plateau. Surrounded by nature, she seeks to live intentionally, practicing poetry as a means to connect with herself, her kindred and her personal ecology.

Rogers, Jackson: *Monk*
Born in the Blue Ridge Mountains, Jackson was initially inspired by the luscious landscapes of southwest Virginia. His interest in photography blossomed under his mother's guidance and expanded during his world travels. In addition to his artistic pursuits as a photographer, Jackson toured nationally in a band before settling into his profession as a geologist.

Rogers, Jeri Nolan: *Rising Star*
Jeri Rogers is the founder of *Artemis Journal*. As a social activist, the Journal was born in 1977 during her tenure as Director of a Women's Center where she created the Journal as a means of expression for her clients. She operates her publishing and fine art business from her Barn Studio in Floyd, Virginia and at jerirogers.com.

Scott, Tricia: *String Theory*
Tricia Scott is a mixed-media artist, photographer, and homeschooling mom. She grew up in Franklin County, Virginia. After living in Atlanta and New Jersey, she settled in Roanoke, finding home in an old farmhouse with a sunny yellow art room at the top of perfectly creaking stairs.

Steger, Kurt: *Green Tara*
Kurt currently works out of his Brooklyn, New York studio. His work has been exhibited widely in California and Virginia, with three California public art comissions including *The Elders*, a traffic circle tribute to those who inhabited Grass Valley. Kurt views his sculptures as collaborations with nature and hopes his work evokes a deep sence of connection to a primal place.

Stout, Barbara: *Always the White Whale*
Before retiring to Virginia, Barbara Stout taught English and creative writing at Kent School, Connecticut, where she received an Honorary Teaching Chair in 2005. Her publications include a collection of haiku, a chapbook, and poems published in journals such as *Amelia, Snowy Egret, The Lyric, and Hellas*. She was interviewed as a poet by Virginia's National Public Radio in October 2012.

Terrill, Camille: *Dragonfly*

Camille Terrill is a Blue Mountain High School student who was taught to be a part of nature and live in harmony with it rather than to look at it as thought it is something separate from human kind. She has fallen in love with seeing life through different perspectives she has gained through her experiences with photography.

Terrill, Rachel: *Serendipity*

Rachel Terrill is a 11th grader who grew up surrounded by farm animals and raw mountain nature. She wanted to capture the beauty of the world she saw around her, and bought her first camera four years ago. She named it Romeo, after the Shakespearean character, because that camera was her first love.

Wallace, Dusty: *Black Bear*

Dusty Wallace lives in the Appalachian Mountains of Virginia with his wife and two sons. He enjoys reading, writing, photography and the occasional fine cigar.

Warstler, Brad: *Fish Plate*

Brad Warstler is a selftaught artist, woodturner, and furniture maker. He has maintained a woodworking studio in the mountains of southwest Virginia since 1977, selling to galleries and taking furniture commissions. His work reflects an uncluttered sense of strength and function with a quiet attention to joinery and finish.

West, Pat: *Before Daybreak*, *Living with chickens*

Pat West lives and works in Giles County, Virginia, and is thankful to be able to careen about between painting, sculpture, gardening and sometimes writing.

Wiseman, Dave: *The road-trip that was suposed to save our marriage*

Hillbilly bibliomancer, unindicted co-conspirator, and occasional stone-mason, Dave has met the devil and came away from it with no more than a few bad habits and a prescription. He write poems because the universe is falling apart like a toilet paper submarine, and someone must point at it and laugh. His recent work has appeared in a number of online and print journals.

Woo, Nancy Lynee: *New Mexico Sea*

Nancy Lynée Woo is fortunate to have a lovely poetry home in Long Beach, CA with the fine folks of The Poetry Lab. Her work has been published or is forthcoming in *The Subterranean Quarterly*, *CHEAP POP*, *Cadence Collective*, and *Cease, Cows*. She is currently working on her first poetry chapbook.

Yun, Esther: *Abalone Dive*

Esther an undergraduate at the University of California at Davis, majoring in Psychology and English. She is published in the *Nameless Journal*, *The Winter Tangerine Review*, and an upcoming edition of *Dirtcakes Journal*. She is also the winner of the 2013 Celeste Turner Wright Poetry Award, and a finalist in the upcoming California statewide Ina Coolbrith Prize in Poetry.